celtic
ornament

art & the scribe

Ex Ubris

Celtic
Ornament

Art of the scribe

Courtney Davis

additional text & calligraphy
by fiona graham-flynn

BLANDFORD

A Blandford Book
Paperback edition first published in the UK 1997 by
Blandford
A Cassell Imprint
Cassell Plc, Wellington House,
125 Strand, London WC2R 0BB
Previously published in hardback 1996

Distributed in the United States by Sterling Publishing Co., Inc.,
387 Park Avenue South, New York, NY 10016–8810

British Library Cataloguing-in-Publication Data
A catalogue entry for this title is available from
the British Library

ISBN 0-7137-2610-5 (Hardback)
0-7137-2547-8 (Paperback)

Designed by Richard Carr
Printed and bound in Great Britain by
Hillman Printers (Frome) Ltd

Contents

If you take the trouble to look very closely, and penetrate with your eyes to the secrets of the artistry, you will notice such intricacies, so delicate and subtle, so close together and well knitted, so involved and bound together, and so fresh still in their colourings that you will not hesitate to declare that all these things must have been the result of the work, not of men, but of angels.

Gerald of Wales, late twelfth century (translation by O'Meara, 1982)

To the memory of George Baine

Acknowledgements

My thanks go to the many friends around the world who have given me so much inspiration while I created this book. Also to Amanda Fearnhamm for her untiring work on my behalf. To Stuart Booth and Cassell for their help and understanding. To Mike and Laura Elliott, Dimity and Blaine, and my Mother. And to Fiona Graham-Flynn for her help with the text and fine calligraphy.

Before Christianity

BEFORE BRITAIN AND IRELAND were Christianized, the Celtic nation lived a pagan tribal life. They were farmers, artists and warriors, worshipping the natural aspects around them: the sun, the moon, the stars and the Earth Mother. The term 'Keltoi' was given by Greek writers to a race of 'barbarians' who emerged from the Rhinelands of Central Europe as a distinct group of clans or tribes between 1000 and 500 BC.

The earliest remnants of their Celtic culture date from between 800 and 450 BC and are attributed to artists of the Hallstatt period, named after archaeological finds found in a cemetery in Hallstatt, Austria. These outstanding finds include many stylized bird, animal and human representations, crafted with such mastery and fluidity of line as to give the impression of life and movement.

Between the fifth and fourth centuries BC a new style, known as La Tène, named after a site on Lake Neuchâtel in Switzerland, appeared. Paul Jacobsthal, a distinguished student of this period, describes it as 'an art without a genesis'.

With its characteristic abstract symbols, floral patterns and imaginative decoration, the distinctive La Tène style was to provide inspiration for the artists who created the illuminated manuscripts and intricate stonecarvings in Britain and Ireland over a thousand years later.

Although many of the elements associated with Celtic art were adapted from other sources and modified, the wonderful artistry of the Celts was widely known, and in particular their craftsmanship in metalwork, where elaborate and fine detail on jewellery and armour were produced. Torcs, bracelets, rings and other jewellery, as well as drinking vessels, horse decorations and swords worked in gold, silver and bronze have all been found. Using their skills with enamels, plating and casting, the Celts created articles which are hard to match even today.

The Celts kept no written records but had an oral tradition, so all important events that needed remembering, as well as themes which revolved around their heroes, gods and beliefs, were learned largely by continuous repetition as chants or were woven into prose form. These were recited by the bards in a way that was both entertaining and imparted knowledge down through each generation, and great merit was attached to accurate recitation.

With the arrival of the Romans in the first century AD, British Celts experienced massive disruption. Christianity was introduced in the following centuries, and the old beliefs became absorbed into the new faith. With the gradual conversion of the Celts and the eventual Roman withdrawal in the fifth century AD, a new era of Celtic Renaissance began.

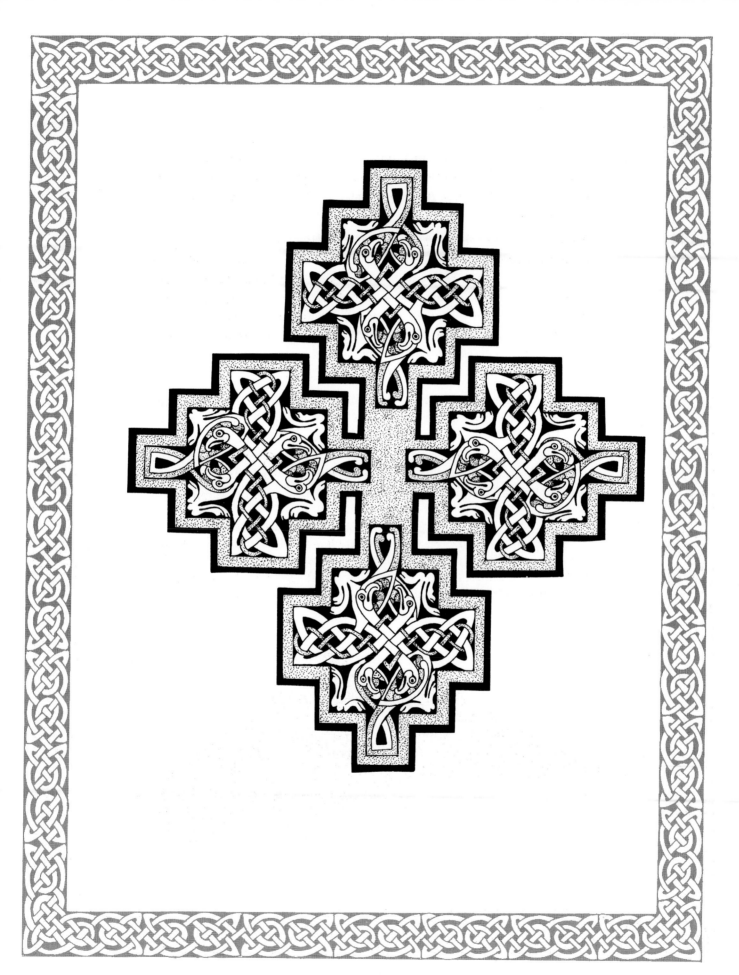

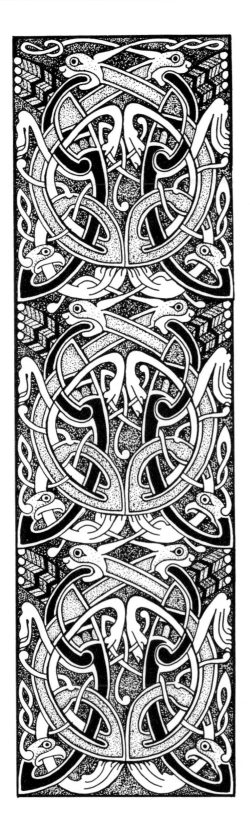

The Spread of Christianity

JUST AS THE NEW RELIGION was beginning to take root in England, it was almost entirely swept away by the Anglo-Saxon invasions. Christians who escaped the sword fled and took refuge in Wales and Cornwall. Meanwhile, England remained under the domination of the Anglo-Saxons for nearly two centuries.

Christianity spread rapidly in Cornwall, Wales and the south-west of Scotland. In AD 432, at a time when England was relapsing once again into paganism, St Patrick was stepping ashore in Ireland – not this time as a slave, as he had been before, but as a missionary to convert the Irish High Kings and their people to the Christian faith. His success was partly due to the fact that he was able to convince the High Kings that a Christian church in their realms would bring them the orderliness and efficiency that men still thought of as characteristic of mighty empires, such as the Roman Empire. St Patrick challenged the authority of the Druids by building many of his churches in known sacred oak-tree groves and establishing them with bishops and priests. He founded the metropolitan church at Armagh in AD 444. He also made use of some of the old pagan customs, absorbing them into the new faith so that it was easier for those who had trusted one religion to turn to another.

St Patrick died in AD 461.

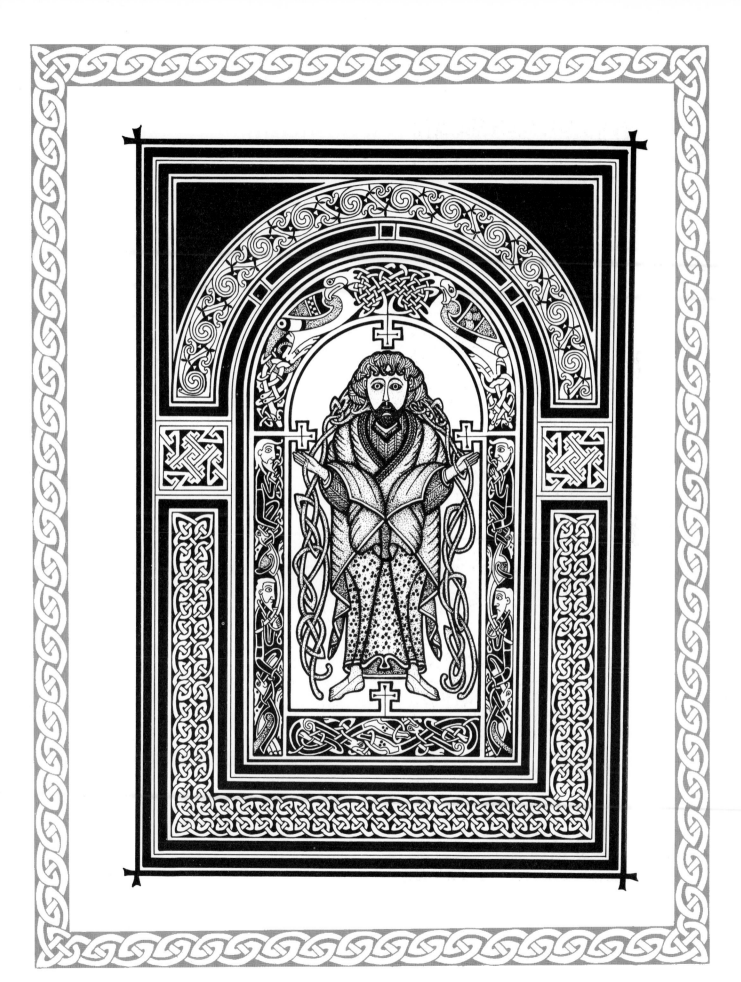

Ascetic Monasticism

IRISH CHURCHMEN SOON LEARNED of a new form of devout worship which originated in the very region where the Christian faith was born: Syria, Palestine and Egypt. These new ideas included deliberately seeking out extreme hardship in the desert, embracing lonely prayer and solitude, rejecting all wealth and devoting one's entire life to God. This practice of ascetic monasticism soon took hold in the British Isles and many simple-living communities were set up in the most desolate and remote places imaginable, superseding the episcopal form of Christianity.

St Enda was said to be one of the first to accept these new Eastern ideas and in AD 490 the King of Munster granted him the three Aran Islands, a group of almost barren islands off the coast of Ireland which are nothing more than broad shelves of rock rising 300 feet out of the Atlantic and battered by the sea. On the largest one of these he and his 150 followers set up a monastery. In time the island became covered with little stone churches and the cells of the monks. Life was very tough. The soil was thin and stony, and it was only just possible by adding layers of seaweed to it, to grow a few

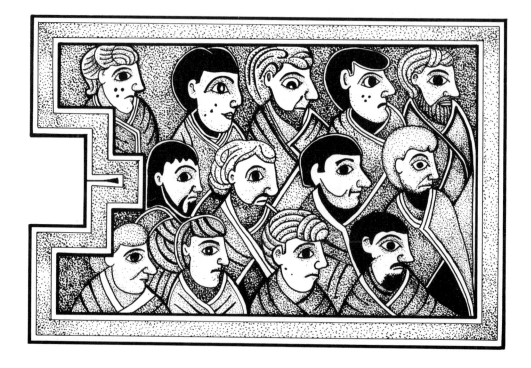

beans and pasture a few goats. In time, several of the monks who learned their faith under St Enda moved on elsewhere to found settlements of their own. Many of the monasteries were on islands off the coast or in the lakes of Ireland, and the most lonely and spectacular of all was the Great Skellig, a pyramid of bare rock off the furthest headland of south-west Ireland which rises to a peak 700 feet above the Atlantic. Near the topmost crag, the buildings of an early monastery, that of Skellig Michael, dedicated to St Michael, nestle on the terraced slope of a rock shelf. Small drystone buildings sit behind a stone-wall enclosure that crowns the brow of a 500-foot precipice. The early buildings consist of six beehive cells and two little oratories. Inside, the cells are remarkably smoothly finished. They were provided with stone cupboards, all were paved and drained, and they still remain weatherproof today. The date of the monastery's foundation is unknown.

Irish monasticism differed in two important respects from its Egyptian prototype: from the outset the Irish monks, unlike the Desert Fathers, valued letters and learning; and, almost from the outset, the Irish monastic movement was a missionary one.

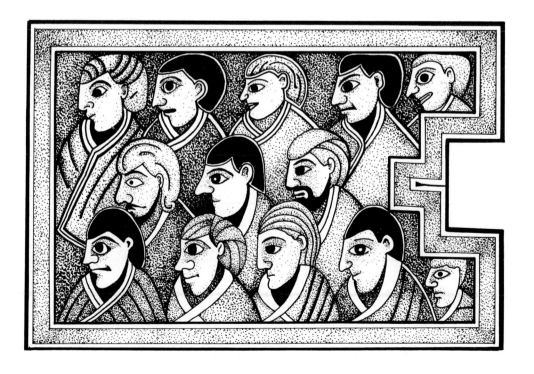

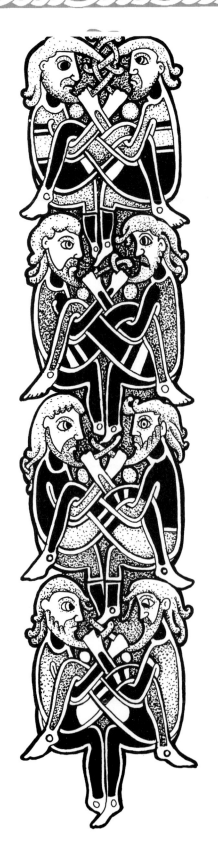

The Celtic Monasteries

O F CLONARD, LIKE MANY of the early great monasteries of Ireland, there is very little visible trace now, although at its height the monks, scholars and students there would have numbered thousands. Through literature on the lives of the saints we have ample evidence of the character of the monasteries. They were usually set within a circular fort-like enclosure called a *cashel*, bounded by a stone or earthen bank with a ditch outside. The church or oratory, a rectangular structure of oaken planks or of wattle and daub, was the most important building within the enclosure. It was often small because solitary prayer, rather than frequent services for all the monks together, was held to be correct. To make up for their small size, there were many of them – at least seven in St Kevin's monastery at Glendalough, for example. On top of several of the tenth-century high crosses can be seen replicas of those small wooden churches and oratories.

The monks lived one, maybe two, to a *cellae*, which was a small, wickerwork hut dispersed about the enclosure. The other buildings of importance were the *tech noiged*, a guest house, the refectory, *praind tech*, and if the monastery was important, there was also a school where Latin and Greek were studied. From the writings of St Columbanus, it is clear that he was well acquainted with the works of Virgil, Sedulius Dracontius, Ausonius, Gildas and many others, as well as the Scriptures, and could deal confidently with philosophy and theology.

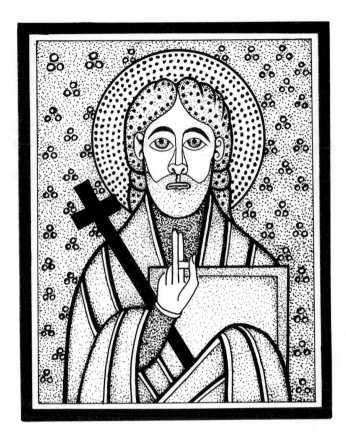

Reading of some of the books on the lives of the saints suggests that the communities very much carried on the arrangements that had previously existed in Celtic societies, especially education by the Druids, which was taken over by the monks.

The life of the monastery was devoted to prayer, penance and learning, but the provision of food for the community was also necessary, as were building skills and the ability to make vessels for the altar, boats or other conveyances, and much more. In time, the monastic workshops became the chief centres of craftsmanship in the country. Food was sparse and not designed to be attractive. The staple diet was bread, beans and occasional vegetables, supplemented by fish, fruit and dairy food, but rarely meat. Monastery rules decreed that monks were to have only enough to keep them alive, but not so much as to burden their stomachs and take their minds off their religious duties.

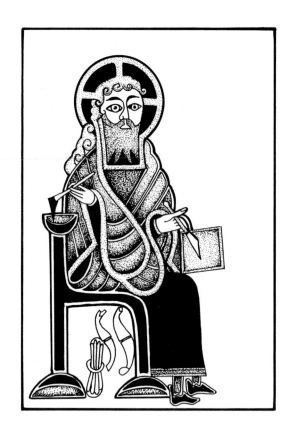

The Monastic Life

IN THE EARLY DAYS of the monasteries, buildings were made of wood – a tradition from Ireland. Later buildings were made of local stone. Life was extremely hard for monks, all of whom followed the rules laid down by St Benedict for monastic orders. The day began at 2 a.m., when communal prayers known as matins were said. The monks spent most of their day in prayer, no matter what other tasks they had to undertake. They grew their own food and this had to be tended. There would be corn to be threshed and winnowed, bread to be baked in the kitchens and bakehouses, live-stock to be fed and fish to be caught. They attended to the beer and mead that was brewed especially for the monastery; these were the usual drinks of the monks, though there was also water. Herbs were of special importance, for their culinary and medicinal use. Simple but wholesome food was served in the refectory, where everyone ate. Their day finished with the prayers known as compline in the late afternoon or early evening.

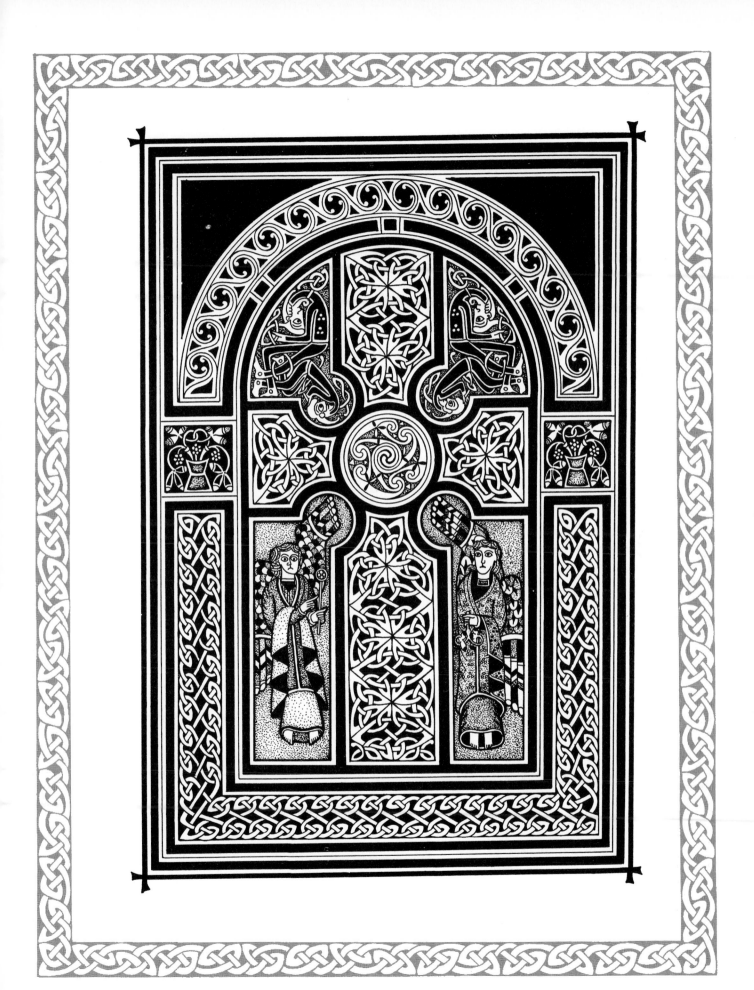

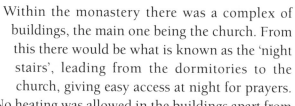

Within the monastery there was a complex of buildings, the main one being the church. From this there would be what is known as the 'night stairs', leading from the dormitories to the church, giving easy access at night for prayers.

No heating was allowed in the buildings apart from the fire which was always lit in the warming house, where the monks could gather and talk, as the rule was silence everywhere else in the monastery. The warm room was next to the refectory on one side and the chapter house on the other, where the monks would carry on the official business of the monastery. The name chapter house comes from the fact that meetings began with the reading of a chapter from the monks' particular monastic rule. Above the chapter house were the abbot's or prior's quarters. They had separate lodgings from the other monks, with a room for entertaining important guests.

The cloisters were where the monks could take daily walks for contemplation or sit and read. Commonly built to the north of the cloisters were the scriptorium (see opposite) and the library.

Larger monasteries would have an outer court and a guest house for visitors such as pilgrims, as they would not be allowed in the monks' quarters.

The Scriptorium

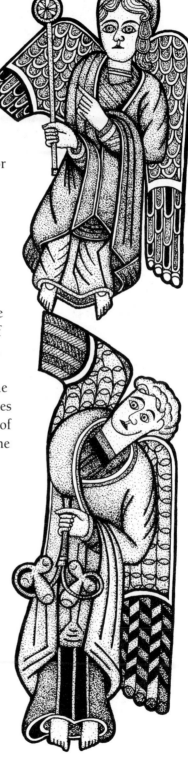

ADJOINING THE LIBRARY would be the scriptorium, where the learned monks would work creating the illuminated manuscripts. A monk known as the armarius was responsible for issuing the writing materials and equipment to the scribes. This was a cold workplace and the monks would sit for as long as six hours with no artificial light, working in silence at a slanted desk. Around a monk's waist would be the diptiych, an open, two-sided wax book or tablet used to make notes. He could open this and write with a stylus of metal or bone into the wax. The monastery needed a wide range of books for their library: some were books of religious study and moral instruction; others were the lives of saints and documents such as deeds and letters, biblical texts, psalters and missals. Some scribes were better educated than others and mistakes were often made in the spelling or the translation of the Latin; some corrections were made but, as in the Book of Kells, they remain to this day.

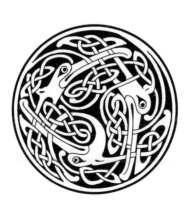

Writing Materials

THE EGYPTIANS USED PAPYRUS to keep their records. This was made by laying reeds criss-cross, and pressing them together, but the surface was rough and difficult to work. The reed pen used as the writing tool meant small and fine letters were impossible to write.

With the introduction of parchment – the name given to any animal skin used for writing purposes, such as sheep, calf and goat, although vellum was originally the word used for calf skin – a smooth surface was possible. Preparation of the skins for writing was a lengthy process and has changed little throughout the centuries.

The skins were first soaked in water to clean them, then put into vats containing lime and water, which washes out some of the fats and soluble proteins and also loosens the hair on the skin. The hair was then pulled away and a blunt knife used to remove the surplus flesh and fat. Sometimes the skin would be split into two, depending on the thickness of the hide used. The monks would return the skins to more lime vats and then give them a final wash. Stretching was the next stage: cords attached to the outer edges of the skins were tied on to rectangular frames. Any fats or oils that remained were removed at this stage by applying a paste of lime, ashes or alum. The skins were scraped down again with a blunt knife. They were left until dry, then cut and finished by rubbing pumice stone into the skin, thus making the surface smooth for writing on what is called the 'nap'

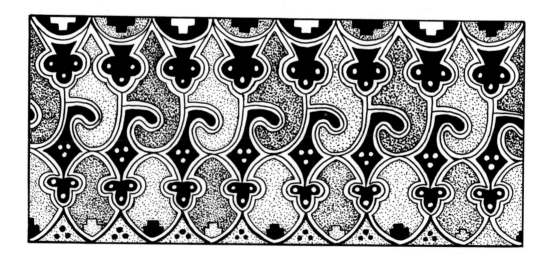

surface of the skin. Consequently each skin had its own unique quality: sometimes tiny black dots were left on it – this was where the hair follicles were; it could be white or yellow in colour. All these factors added to the texture and look of the page.

In some cases the spine of the calf can be seen running down vertically with the spine of the book. It is calculated that the Book of Kells used more than 185 calf skins to complete the manuscript. Some of the calves were killed especially, when they were between two and three months old, for the quality of the skin, though because of their size they might be used for only one page.

Pens

THE FIRST PENS TO BE USED were cut from bamboo or reeds by calligraphers in the East and the Egyptians. They would work on papyrus but, as we have seen, the rough surface meant it was difficult to control the writing.

Later, feathers were used to make writing pens, called quills. These were taken from the strong flight feathers of large birds such as geese, swans or sometimes crows. The name pen comes from the Latin *penna*, meaning feather.

The quill was made by cutting the end of the feather, soaking it in warm water and removing the membrane inside the tube, then inserting it in hot ashes for a short time to harden. Finally a series of cuts was made to shape the point of the quill ready for use over long periods without any need for resharpening.

The flexibility and durability of the quill, in combination with the production of the parchment, revolutionized fine writing of that time, and it remained the only tool for the job for centuries to come.

Pigments

THE PIGMENTS USED BY THE SCRIBES came from various sources, plants, animals, minerals and so on. For example, indigo was obtained from the roots of a plant from India; black was made from the soot of burned bones; raw sienna and yellow ochre came from natural earths. In the main, pigments were used by the monks because of their brilliance and luminous quality; they were easy to apply by quill or brush and the colours lasted, apart from ground malachite (green) and azurite (blue), which would fade or discolour unless enclosed within a suitable acid-free binding. The scribes learned these facts over the centuries and many references to the appropriate tempering of different pigments occur in their 'recipe' books. Vermilion red, for example, is a compound of mercury and sulphur. It is of a brilliant hue and was favoured by the scribes because of its good opaque qualities, although it was not used next to emerald green, because it would blacken the red. Some pigments from the earth – for example, iron oxide – did not fade in light. Genuine ultramarine blue – lapis lazuli, a semiprecious stone from Persia and Afghanistan – was the most prized of the pigments used by the scribes. Second to this was azurite blue (azzurro della magna). Both were ground down to make the pigment and mixed with a medium of egg yolk and water. If properly prepared, the colour was neither too green nor too purple but a deep deep blue, and very opaque. Malachite green has been used by scribes throughout the centuries. It is carbonate of copper and becomes luminous on the page when tempered with size. Yellows and browns such as yellow ochre, raw sienna and burnt umber, were obtained from earth pigments and were very permanent on the page. The basic colours used in illumination were red, blue and green. For lettering purposes oak galls and iron were used; they were never blotted on the page but were allowed to dry naturally, to obtain a deep black colour.

The Illuminated Letter

A living reading of the Lord's story for those who cannot read.
Pope Gregory the Great

ILLUMINATED LETTERS WERE PAINTED on the page by the monks for the greater glory of God. Intricate and detailed in their decoration, they punctuated the text and aided legibility, and were a visual way of conveying the power of the Word of God.

In the early forms of illumination there tends to be a large uncial letter with animal heads and feet or Celtic beasts entwined, plus spirals and interlacing.

Many of the lesser initial pages were overshadowed by either a carpet page or a grander initial page, so some of the early manuscripts would further enhance the lesser illuminations by surrounding the capitals with a border of red lead dots called rubrication, providing a background which would lift the initial off the page. On one page of the Lindisfarne Gospels 10,600 dots were counted.

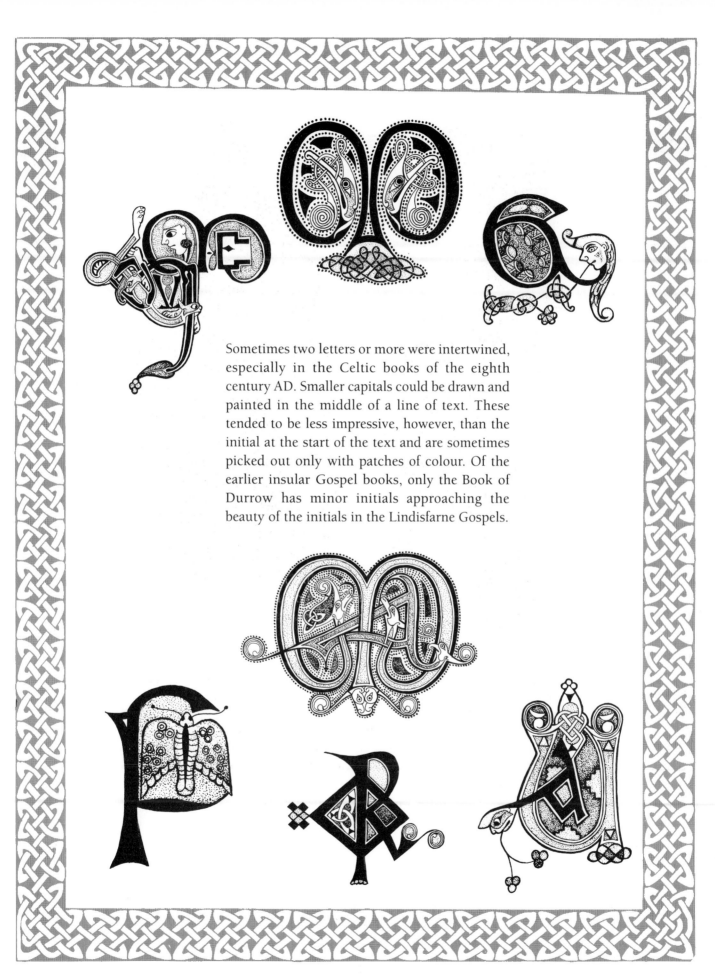

Sometimes two letters or more were intertwined, especially in the Celtic books of the eighth century AD. Smaller capitals could be drawn and painted in the middle of a line of text. These tended to be less impressive, however, than the initial at the start of the text and are sometimes picked out only with patches of colour. Of the earlier insular Gospel books, only the Book of Durrow has minor initials approaching the beauty of the initials in the Lindisfarne Gospels.

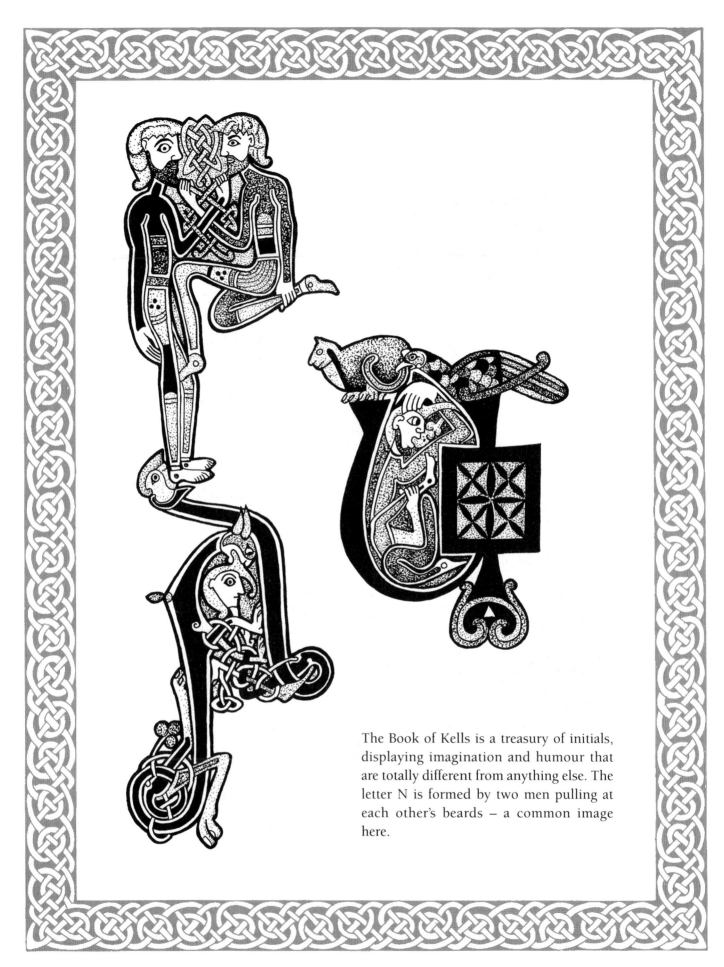

The Book of Kells is a treasury of initials, displaying imagination and humour that are totally different from anything else. The letter N is formed by two men pulling at each other's beards – a common image here.

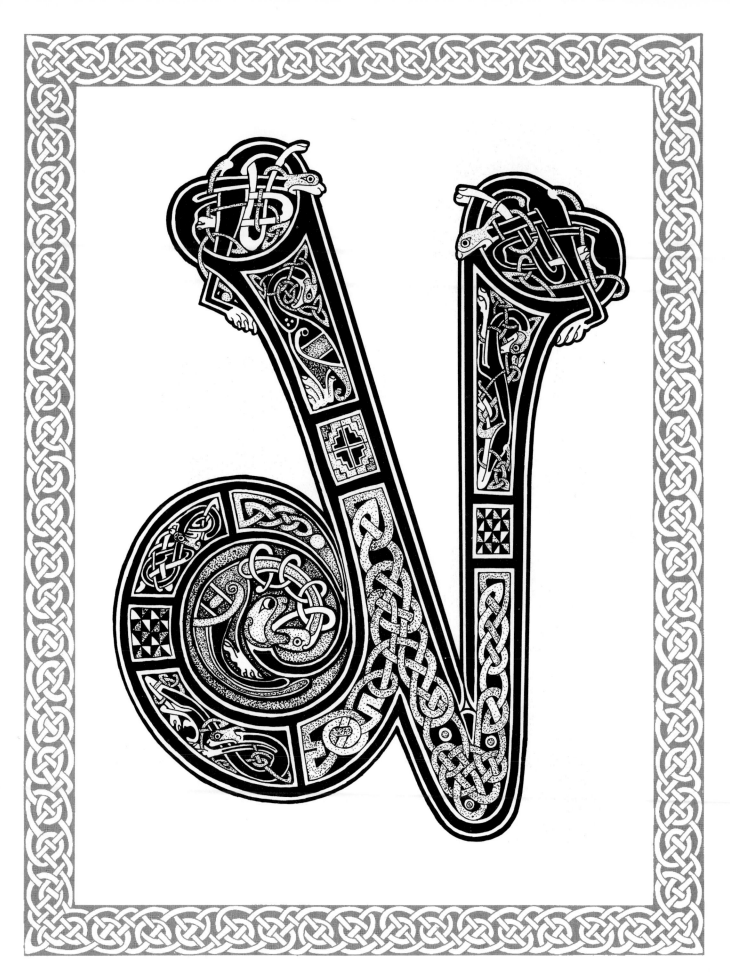

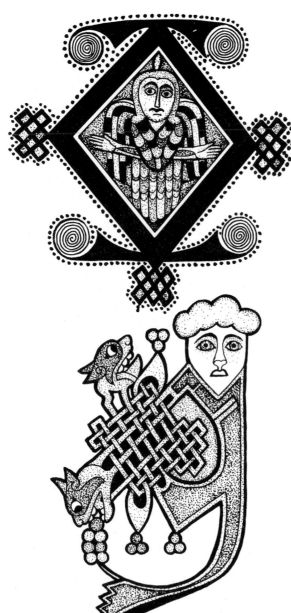

Many of the minor initials appear to have been inspired by certain text in the Gospels and scribes have illustrated the events within the initials. It has been suggested that some of the figures may be representations of Christ and other biblical figures or known personages. This is especially true of the Book of Kells.

An eighth-century abbot inscribed a riddle about his quill pen:

In kind simple am I, nor gain
from anywhere wisdom,
but now each man of wisdom
always traces my footsteps.
Habiting now broad earth, high
heav'n I formerly wandered.
Though I am seen to be white, I
leave black traces behind me.

(from The Story of Writing *by Donald Jackson).*

he roman hand chang-
ed somewhat
throughout the
centuries. when we
think of rome we
automatically think
of incised capital letters in stone.
a formal precise inscription carefully
executed by the craftsmen of
that time. when the writing of
books began, square and rustic capital
letters were formed. they had moved
from writing with reed pens in
the 1st century to using the quill
by the 4th. the roman cursive
majuscule was formed. from
this developed the roman uncial
and half-uncial. used as early as
the 4th century and throughout
monastic society, this kept the
script alive.

ounded shapes of the formal uncial scripts were used to copy and recopy the early bibles and gospel ✤ ✤ books. In 476 the christian monks from rome were pushing further west to gaul and on to ireland. celtic monasteries sprang up as monks from rome landed in ireland, the most famous being st patrick, who brought with him books of learning. from these a new script grew, the irish half-uncial.

erhaps because these monks were far removed from rome, ❀ ❀ the script changed slightly. they lived in remote places and mixed with celtic tribes, who had their own art form, with interlacing knots and spirals. the half-uncial and uncial scripts were ⋮ also used in britain because of the influx of monks from ireland to the shores of iona. from there christianity spread down to lindisfarne, wearmouth and jarrow. the monks brought with them the art of the scribe. so began the great schools of anglo-saxon art.

Famous books such as the book of durrow, the book of kells and the lindisfarne gospels were all written by scribes in the 8th century in insular half-uncial or uncial script, executed with such mastery, the quill seems to move over the page with apparent ease. the scripts were written with the quill held at a flat angle to the vellum. they have pleasing roundness to the eye, are quick to write and easily read. these monks leave us such a fine example of calligraphy and beautiful illumination that even by today's standards they cannot be equalled.

t the end of the 7th century the uncial and half-uncial began to fall into decline, and the change from majuscule letters to the minuscule script gained popularity in the nation. In 742 Charlemagne was born. He was King of the Francs for 46 years. It was through him that a new written hand emerged. He surrounded himself with scholars from many countries and set up schools of writing in Europe. The anglo-saxon monk Alcuin of York, who was in one monastery, was sent to the Abbey of St Martin, Tours, to supervise the school. In one of his poems is developed the style known as the carolingian minuscule.

he schools were of a high standard where the copying of classical texts was executed. This new script had a remarkable clarity and a beauty of its own. It became widely accepted throughout Charlemagne's domain. It was a mixture of several distinct styles, all of which developed from the classical Roman cursive used earlier in the 4th century church. It was brought to Britain, and by the 10th century was used at one of the founder monastic schools, that of Winchester. It gained recognition, being used in the writing of great books such as the Winchester Bible and the Benedictional of St Ethelwald.

he letters were easily read and spacious on the page. In the scriptorium the scribes who wrote these beautiful books were highly trained and this particular script had rules on how to form the letters, also what angle to hold the quill pen on the vellum or parchment. Unfortunately sometimes old texts were scraped away from the vellum pages of existing books and re-used for new writings. It is tragic to think of such treasures that were destroyed with this process.

y the early 12th century the medieval monasteries were using professional lay scribes alongside the monks in the scriptoria, as the work of the scribe had slightly changed. There was still a need for books not only for the church but for rich people. Prosperous merchants required professional scribes, so workshops and guilds were formed in cities throughout Britain. The books now written were for noblemen, lawyers, educated men and prayer books for rich ladies.

I n turn this lead to the setting up of universities and schools which had nothing to do with the church. Many psalters were written at this time. Through the last two centuries the carolingian script had become condensed, giving way to a cursive gothic script, still keeping its curves at the top of the letter, but looking straight and angled at the bottom.

Colum-cille

THERE ARE MANY LEGENDS about the passionate spirit of Irish people who devoted themselves to scribal work, and the most famous of these was Colum-cille, who was born in AD 521 in Donegal and would later be known as St Columba.

He was a direct descendent of King Niall, and a cousin of the king who now ruled over north-west Ireland. He was determined to become a priest and studied at several of the monastic schools, including Clonard. He also learned the older skills of poetry that had been taught by the bards, and in later life he would defend them against Christians who sought to end such relics of the past.

Colum-cille set up his first monastery on the great stone hillfort of Grianan in Derry, and in the following years he journeyed across Ireland, setting up other monasteries at Durrow, Kells and Swords in Meath and on the lonely Tory Island off Donegal.

In AD 560 Colum-cille quarrelled with another abbot, the owner of a book he had copied without asking permission, and the abbot now claimed that the copy should rightfully be his. Colum-cille was furious at the High King's support for the owner of the book and, in his anger, he raised an army. They fought a great battle on the slopes of Ben Bulben which ended with the death of the High King. With this the Church was triumphant, as the king had been the last great enemy of the Christian monks in Ireland, and from AD 561 the monasteries dominated the Irish way of life.

In AD 563, driven by a call to convert the Pictish people of Scotland as well as the territory occupied by the Anglo-Saxons, Colum-cille set off with twelve disciples, leaving his native country behind in 'exile for Christ' and the windswept island of Iona. With the permission of the Pictish King of Dalriada, to whom the island belonged, he established the famous

monastery there, which became the mother house for the Columban monasteries in Ireland. So widely respected was Columba that when the King of Dalriada died, the Scots turned to him for advice on who should succeed. He chose a prince named Aidan, who was blessed by the abbot and duly enthroned.

In time Columba's followers founded many small monasteries and Celtic churches, and high crosses and monastery walls began to spread over the western parts of Scotland.

Even after the death of Columba in AD 597 his influence and that of his monastery on Iona continued to spread, and in the next century missionaries from Iona would travel across the heathen lands of the Anglo-Saxon invaders to reach Northumbria and found a monastery on the island of Lindisfarne.

In the same year as the saint's death, St Augustine arrived on the shores of Kent from Rome to convert the pagan Anglo-Saxons. When the Anglo-Saxons were converted themselves by St Augustine, in their acceptance of the new faith they agreed that all knowledge and records would now be written down rather than memorized. This also meant that instead of suppressing the pagan artistic traditions of a people it came to convert, the new faith encouraged their help, and this had a revitalizing effect. As the two cultures of the Anglo-Saxon and Celtic people began to interrelate, their two art forms became incorporated and emerged even richer than before. Those same accomplished artisans who had once served the Celtic chieftains now turned their talents to creating works to adorn the Christian altar.

The Cathach

THE EARLIEST SURVIVING IRISH MANUSCRIPT is the book known as the Cathach of St Columba, which may have been written as early as the late sixth or early seventh century AD. It shows the distinctive Celtic half-uncial script. The initials have very simple decoration drawn with the same red and brown inks as the script and many of them are outlined with red dots. There is a clear similarity in the lettering between the Cathach and the later Book of Durrow which points to a shared tradition of scribal practice. The Cathach is traditionally associated with St Columba and, like the Book of Durrow, is said to be in his own hand.

The Book of Durham

FRAGMENT 1

ONLY SEVEN LEAVES REMAIN of this important manuscript, which is the earliest Hiberno-Saxon painted manuscript, recognizable by the suede-like surface that is highly receptive to ink and colour. It was written in the middle of the seventh century AD.

Interlacing appears here for the first time in insular book decoration on the colophon page at the end of St Matthew.

Though the Book of Durham shows the scribes' growing inventiveness with decoration, it is still a prelude to the Book of Durrow.

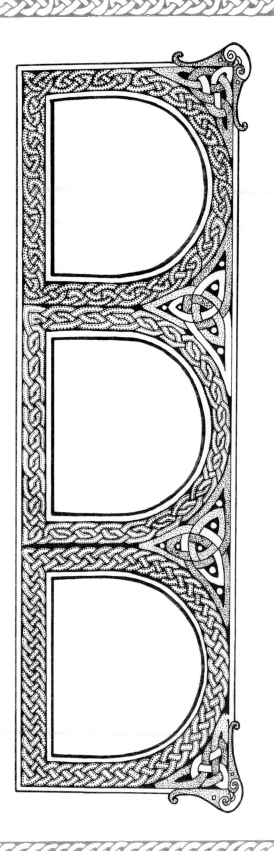

The Book of Durrow

WHEN THE SEVENTH CENTURY was well advanced and the monasteries had grown in size and wealth, a masterly art fit to meet the demand for Gospel books to grace the altar suddenly appeared.

The first elaborately ornamented manuscript was the Book of Durrow, written about AD 680, although its script and the layout of the ornament show it belongs to a tradition already developed by the Irish scribes. A colophon at the end mentions St Columba as having completed the book in the space of twelve days and says that it is copied from an older exemplar.

It is not known what kinds of book were written before, although many must have been copied by converts. The earliest surviving manuscript, the Cathach of St Columba, shows that the Irish scribes had not only developed a distinctive script, which was the Celtic half-uncial, but had also begun to employ a tentative distinctive ornament in their work.

The Book of Durrow is believed to have been written in Northumbria, for the neat elegance of the script is characteristic of Northumbrian work. The text is a pure rendering of St Jerome's Vulgate and is probably copied from one of the manuscripts brought back from Rome by Benedict Biscop.

The painting was clearly done by an Irishman, or one trained by the Irish. He devoted an introductory page to each Gospel, depicting the symbols of the Evangelists, but the symbols ignore the order of the text, following instead the order of the Gospels in the Old Latin version.

It was the earliest of the great Gospel books to include the canon tables and full pages of illumination known as carpet pages. There are three dominating colours in the book: red lead, yellow orpiment and a little green verdigris. The copper acetate which was used has unfortunately eaten through the vellum in some places.

The Book of Durrow was preserved for a long time in the Columban monastery of Durrow in County Offaly, Ireland.

A curious story is told that after the Dissolution of the Monasteries the book came into the possession of a farmer who used to protect his cattle from disease by dipping the book into their drinking water.

Saint Willibrod and the Echternach Gospels

Born in Northumbria, St Willibrod, a Saxon, went from Ripon to Ireland when he was twenty and stayed to study for twelve years before setting off with twelve disciples on his missionary expedition to Frisia (now Luxemburg) in AD 690. There he founded the monastery at Echternach.

After much success he was consecrated in Rome in AD 695 as bishop of the new see of Echternach.

Some of the disciples were expert calligraphers, trained in the Hiberno-Saxon style of writing and decoration, and to one of these artists is attributed the Durham Gospels. They continued to practise their art in their new abode, producing a series of manuscripts, including the Trier Gospels.

St Willibrod kept close contact with Northumbria throughout his life. A monk who was a member of his entourage was cured of a sudden illness at Lindisfarne while on a visit to the resting place of the relics of St Cuthbert.

A copy of the Gospels would have been seen as a fitting gift for Willibrod's new monastery or cathedral, and the Echternach Gospels were probably completed in a very short period of time, perhaps to mark a special event such as a dedication ceremony.

Lacking carpet pages, it follows the Book of Durrow in having full-page pictures of the Evangelists, seen full-length without wings or haloes, together with interlacing and spirals executed with academic precision.

At Echternach St Willibrod's festival is still celebrated today with a dancing pilgrimage to the basilca where he was buried on his death in AD 739.

peace between person and person,
peace between wife and husband,
peace between woman and children,
the peace of christ above all peace.

Extract from the Carmina Gadelica by Alexander Carmichael

The Durham Gospels

FRAGMENT 2

DATED TOWARDS THE END of the seventh century AD though separated from the first manuscript by only a few years, the second and more substantial fragment of a large Gospel book owned by the Cathedral Library of Durham shows a radical change in execution.

The simple knotwork borders of the first book are now transformed into a mass of interwoven quadrupeds and lace-like plaited knots which throng with life and movement.

The perfect economy of the layouts and the design of its ornamental fillings are very similar to the work created by the Master of the Echternach Gospels.

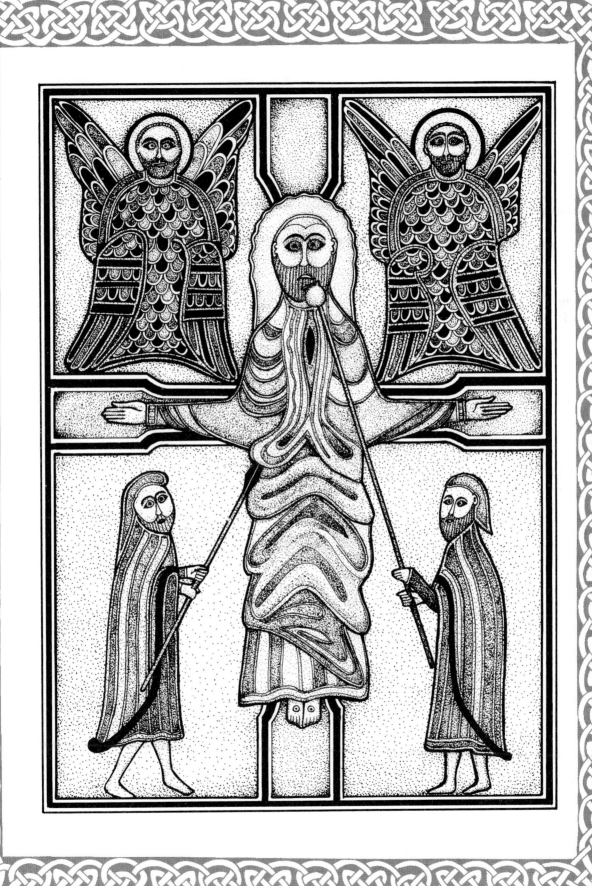

The Venerable Bede

T HE FAMOUS HISTORIAN and biblical scholar the Venerable Bede was famous for his learning and his authorship of the first written account of the history of England, from the Roman conquest to the raids by the Vikings. He also wrote the ecclesiastical history of the English people, and lives of St Alban and St Cuthbert.

He was born on land owned by the monastery of Wearmouth in AD 673 and at the age of seven he was sent to be educated there. His teacher was the monk Ceolfrith. More land was given to the church further along the coast, by King Ecgfrith, and it was there that Bede travelled. At St Paul's in Jarrow he remained in monastic orders and was made deacon when he was nineteen. The library at Wearmouth had an unrivalled collection of books which had been gathered by the abbot on his extensive journeys to the Continent.

Uncial script was brought back into use at Jarrow and it was this style which was used in the Ceolfrith Bible. In the fine scriptoria at Jarrow and Wearmouth the scribes needed to work faster and faster in order to meet the demand for copies of the books being written by Bede, which totalled over forty and were all written in Latin. To keep up with the pressure, the scribes adopted the quicker, insular half-uncial script.

According to medieval tradition, the Durham Cassiodorus was written by Bede.

Bede died on the 25 May 735.

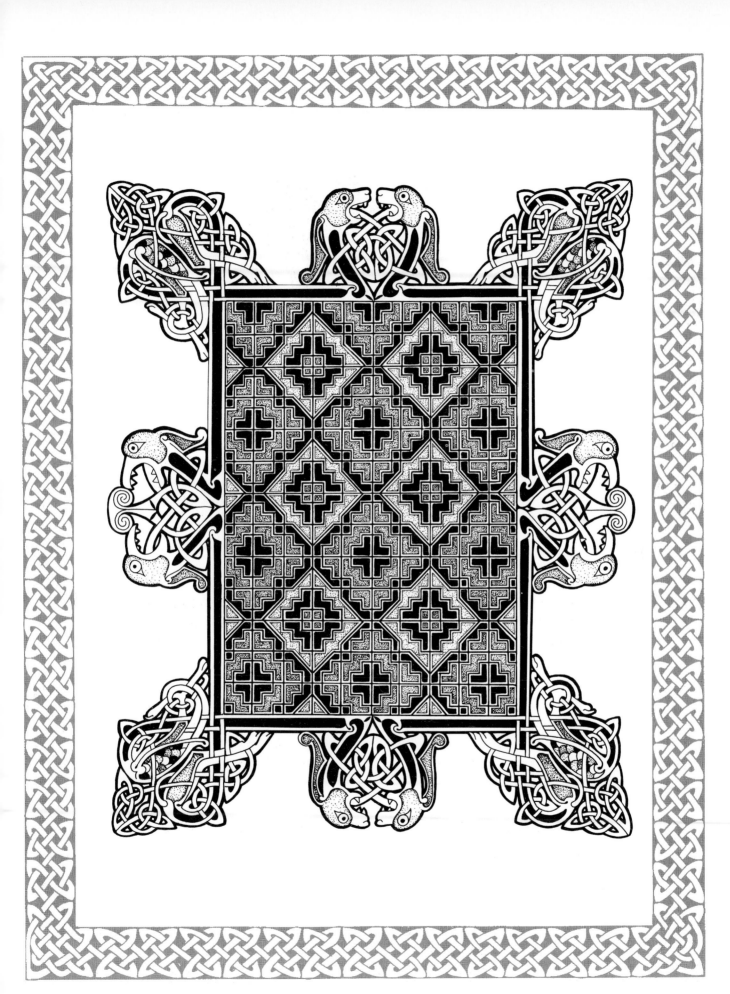

Lindisfarne and its Gospel

Eadfrith, Bishop of the Lindisfarne Church, originally wrote this
book, for God and the Saint Cuthbert and – jointly – for all the
saints whose relics are in the Island. And Ethelwald, Bishop of
the Lindisfarne islanders, impressed it on the outside and covered
it – as well he knew how to do. And Billfrith, the anchorite,
forged the ornaments that are on the outside and adorned it with
gold and gems and also gilded over silver – pure metal. And
Aldred, unworthy and most miserable priest, glossed it in English
between the lines with the help of God and St Cuthbert.

*Aldred's colophon, written on the last leaf of the Book of Lindisfarne,
250 years after its completion*

CELTIC CHRISTIANITY converted Northumbria and led to the establish-
ment there of the great monasteries of Jarrow, Old Melrose, Whitby
and Lindisfarne, the last of which was founded in AD 635 on a small
outcrop of land about a mile and a half off the Northumbrian coast and
built on what is now known as Holy Island.

Twice a day, on the retreat of the tide, a causeway is revealed that links the
island with the shore, and missionaries and pilgrims for centuries have fol-
lowed the tracks across the sand on their journey to and from the holy site.

St Aidan came with twelve disciples to Lindisfarne from Iona at the request
of the Northumbrian prince Oswald when he returned from exile in
Scotland and asked them to found a new monastery there. St Aidan trav-
elled the length and breadth of Northumbria, usually on foot, preaching
and baptizing wherever he stopped, and by the time of his death in AD 651
the Christian faith was well established and other communities had been
founded.

The Venerable Bede wrote of St Aidan in his *Historia Ecclesiastica Gentis
Anglorum*: 'The highest recommendation of his teaching to all was that he
and his followers lived as they taught. He would never have sought or cared
for any worldly possessions, and loved to give away to the poor whatever
he received from kings and wealthy folk.'

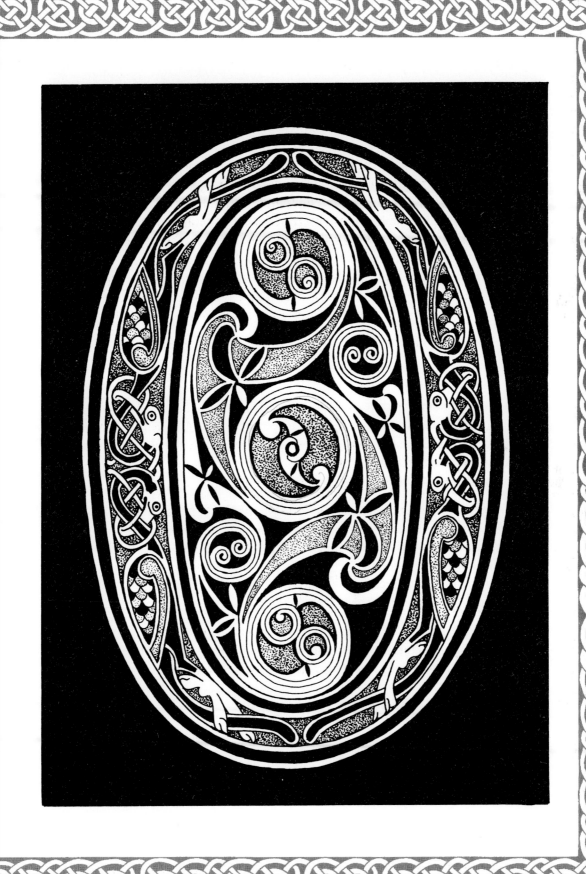

St Cuthbert was born around the time of the arrival of the missionaries from Iona and entered the monastery of Melrose in Lowland Scotland soon after the death of Aidan, whom he had seen in a vision. After a period of study, he was ordained as a priest and began a mission across Northumbria, preaching and administering the sacraments. He rapidly acquired a reputation for his holiness and miraculous powers.

He was eventually sent to Lindisfarne to reform the community there, which had become slack in discipline. At Lindisfarne he found himself attracted more and more to a life of solitude, and he began withdrawing himself to a tiny inlet a few yards off the shore of the mainland which was accessible only at low tide.

Later he built a hermitage for himself on Farne Island, from which he could see nothing but sky, and he lived there alone for a number of years. He was visited by monks and many people who had heard of his saintliness. King Ecgfrith himself came in AD 684 to plead for him to return. Cuthbert agreed and accepted election as a bishop, and was consecrated the following Easter in York by Archbishop Theodore of Canterbury.

When Cuthbert felt that his life was nearing its end, he returned to his hermitage on Farne Island, where he died on 20 March 687. His passing was signalled by a small group of his disciples waving torches. His body was taken back to Lindisfarne for burial. His remains were to stay in the ground only long enough for the flesh to disintegrate, then the bones would be raised, washed and wrapped in fine cloth before being laid in a casket above ground so that he could be visited by the faithful

After eleven years Cuthbert's successor, Eadbert, agreed for the grave to be opened on the anniversary of his death in AD 698. When the grave was reopened, it revealed a body miraculously undecayed. The body was placed in its casket and laid on the floor of the sanctuary and soon many miracles were recorded as pilgrims flocked to the shrine.

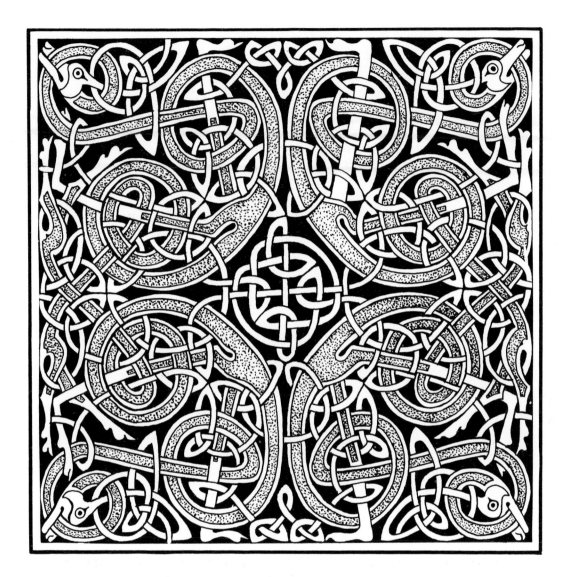

Aldred tells us in the great manuscript of Lindisfarne that Eadfrith, who was later to be Bishop of Lindisfarne from 698 to 721, was the scribe and possibly the decorator also. This skill presupposes some form of training in the tradition of Columban book decoration. It has also been suggested that he may be identified with an Ehfrith to whom Aldhelm of Malmesbury wrote in 686, congratulating him on his return from a six-year stay with the Irish. If this is correct, it explains why the distinctive character of the Lindisfarne Gospels, executed by an Anglo-Saxon artist, should embody the Celtic artistic traditions of Durrow and Kells.

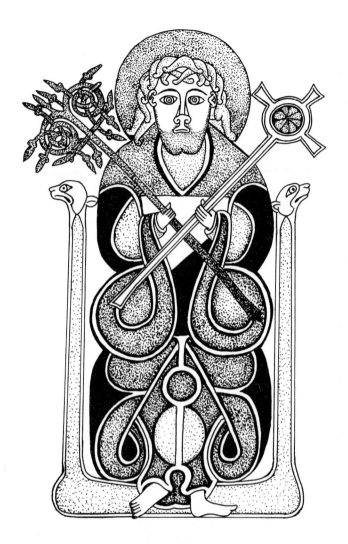

The Gospels of St Chad

THE GOSPELS OF ST CHAD, also known as the Lichfield Gospels, though severely damaged, still display an outstanding beauty with a most striking resemblance to the Lindisfarne Gospels. They were almost certainly in two volumes, the first of which is the only survivor. It is thought that a scribe-artist named Ultan, located in Northumbria, may have been responsible. The *'De Abbatibus'* poem says that Ultan could 'ornament books with fair marking, and by this art he accordingly made the shape of the letters beautiful one by one'. The possible date for the Gospels is around AD 730.

It was not unusual for legal documents to be copied for safekeeping into a Gospel book. In the Gospels of St Chad an inscription on the last page of St Matthew's Gospel reveals that at the beginning of the ninth century AD the book was in Llandeilo-Fawre in South Wales, where it was offered on the altar of St Teilo by Gelhi, son of Arihtuid, who had exchanged his best horse for it. A further marginal addition in the Gospels is the name Wynsy, with a cross beside it; we know him to have been Bishop of Lichfield from AD 974 to 992. So the manuscript had reached Lichfield by the tenth century AD, and has ever since been associated with the name of Lichfield's patron saint, Chad, or Ceadda the great Northumbrian missionary, who was educated at Lindisfarne and died as Bishop of Lichfield in AD 672.

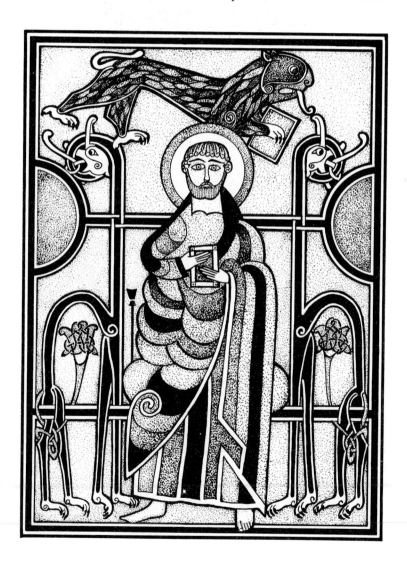

Canterbury

ST AUGUSTINE LANDED on England's shore in AD 596, sent from Rome by Pope Gregory to bring Christianity to the Anglo-Saxons. Canterbury was a royal city, home of King Ethelbert of Kent, and it was here that Augustine came. The first place of worship used by Augustine was an old Romano-British church which is said to lie under the present cathedral.

One year later he founded his first abbey in Canterbury, that of St Peter and St Paul, and from that time on it became famous throughout England as the focal point of Christianity. St Augustine was a Benedictine monk and the rule of St Benedict was followed. It was written that the writing of manuscripts was for the sole purpose of worshipping God and that certain hours of the day should be set aside for manual labour.

Craftsmen should be allowed to practise the arts of the scribe, but they should not be boastful of their skills, or succumb to the temptation of pride, or else they would be removed from their work until they had

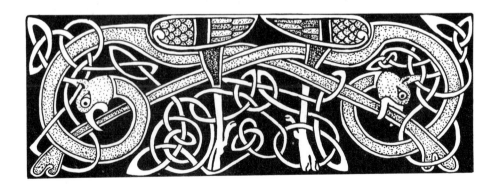

humbled themselves. Eadwin, a scribe at Canterbury in AD 1140, had no such scruples on this matter, for in the margins of a manuscript he was copying he penned a picture of himself, and notes about his work were also written there. In the margins were notes on how the scribes' hands became stiff and frozen, and how they would have to stop writing in the cold weather and wait until it was warmer.

In a letter written by Bishop Milret of Worcester shortly after the death of St Boniface in AD 755, he tells Lullus, his successor in the see of Mainz, that the Canterbury Codex Areus, a manuscript noted for the ancient technique of dyeing the parchment purple, had been lent to Cuthbert, Archbishop of Canterbury. Probably written in the 750s, a manuscript of this splendour, with its gold and silver inks, may well have been paid for by King Aethelbald of Mercia, who was a benefactor of Canterbury and a friend of Cuthbert.

Many other books were written at Canterbury through the centuries.

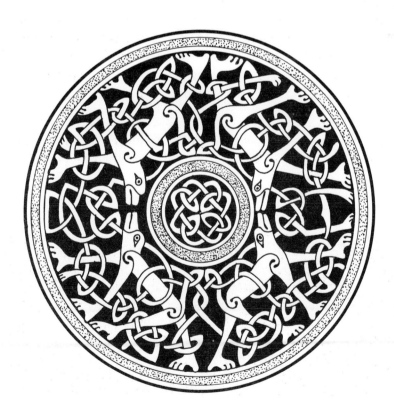

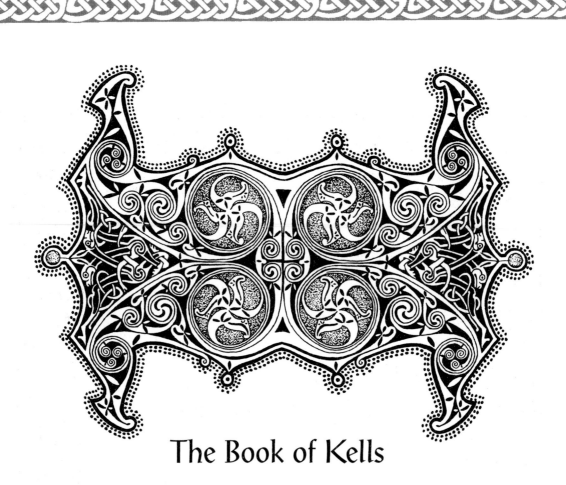

The Book of Kells

T HE FIRST KNOWN RECORD of the existence of the manuscript we call the Book of Kells is an Irish account of its theft at Kells in 1006.

The great Gospel of Colmcille, the chief relic of the western world, was wickedly stolen during the night from the western sacristy of the great stone church of Cennanus on account of its wrought shrine. That Gospel was found after twenty nights and two months with its gold stolen from it, buried in the ground.

The Annals of Ulster *(translated into English by Ludwig Bieler.)*

The Book of Kells holds a unique place in history, with its extraordinary wealth of Hiberno-Saxon illumination. A large manuscript of the four Gospels, it was probably written and illuminated in Iona in the early ninth century AD, and brought from there in an unfinished state when the monks fled the monastery in AD 807, after a series of Viking raids, taking with them the relics of St Columba and other precious possessions to the new monastery of Kells, in County Meath.

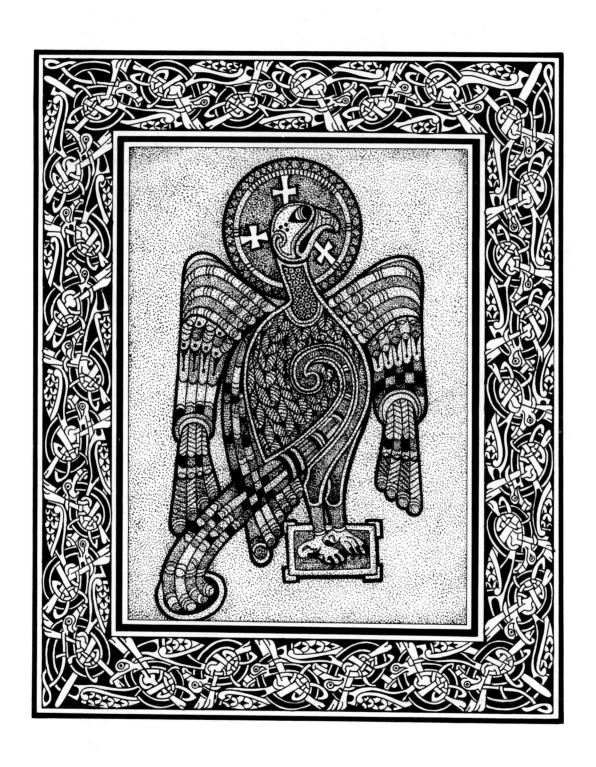

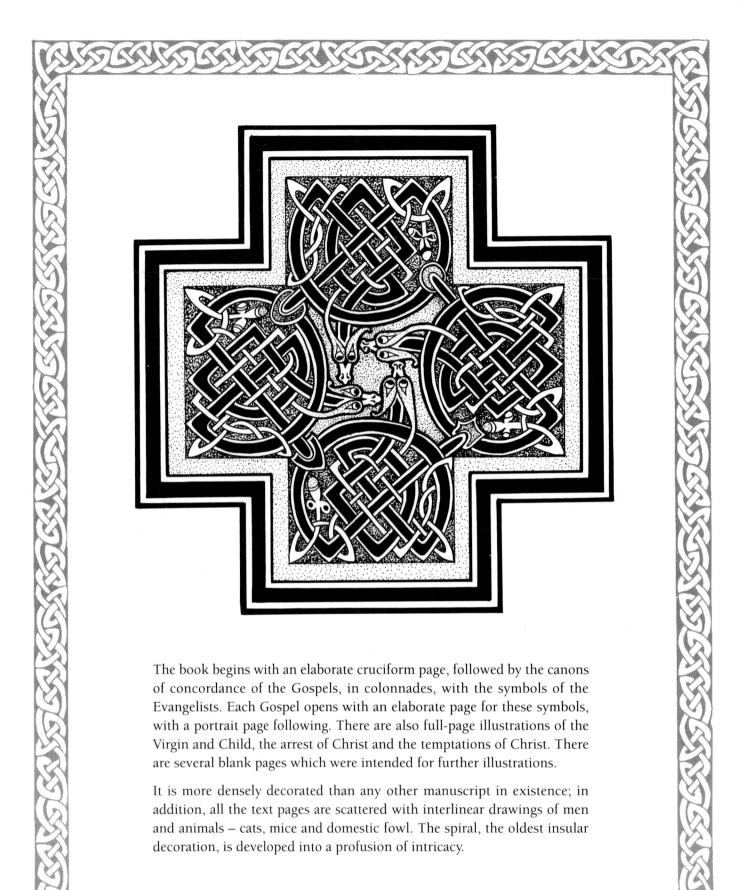

The book begins with an elaborate cruciform page, followed by the canons of concordance of the Gospels, in colonnades, with the symbols of the Evangelists. Each Gospel opens with an elaborate page for these symbols, with a portrait page following. There are also full-page illustrations of the Virgin and Child, the arrest of Christ and the temptations of Christ. There are several blank pages which were intended for further illustrations.

It is more densely decorated than any other manuscript in existence; in addition, all the text pages are scattered with interlinear drawings of men and animals – cats, mice and domestic fowl. The spiral, the oldest insular decoration, is developed into a profusion of intricacy.

Mlle Henry makes it clear that the decorations in the book represent the work of several people, both scribes and artists, working together and she identifies these as 'the Goldsmith', who produces the metalwork effect, 'the Illustrator', whose expertise lies in the painting of figures, and 'the Portrait Painter', who produced the striking compositions.

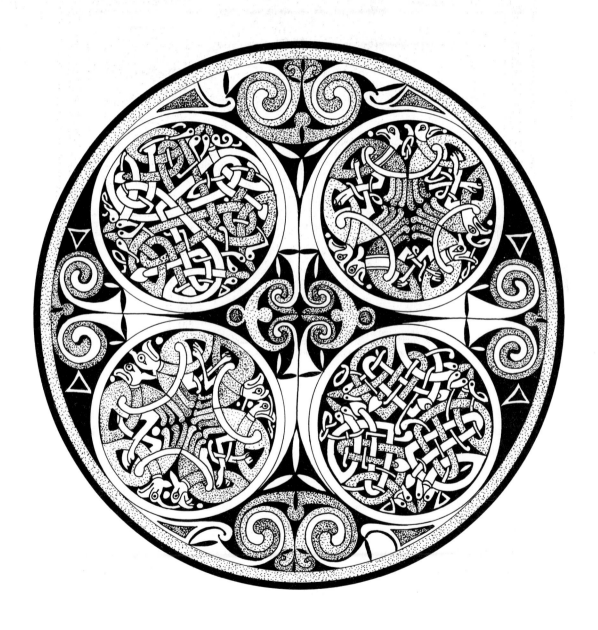

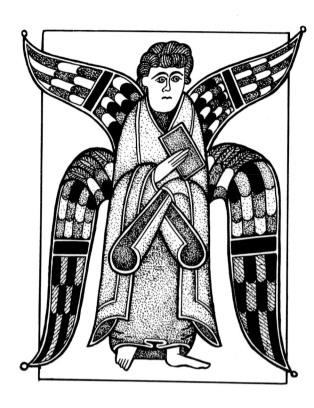

The Book of Armagh

THE NAME ARMAGH comes from Ard Macha or 'Macha's Height', which was named after a pagan queen who built a fortress on top of a hill there. In the fifth century AD St Patrick chose this site to set up his monastic base, and by the eighth centuryAD it had become the ecclesiastical capital of Ireland. An inscription by the scribe Ferdomnach in the Book of Armagh states that it was made for Torbach, who was abbot of Armagh in AD 807, and that besides himself there was at least one other scribe who worked on the book. It is the only early surviving Irish manuscript which contains the complete New Testament, including the canon tables, prefaces and interpretations of Hebrew names. It also contains two accounts of the life of St Patrick and his confession.

The Book of Armagh is perhaps the best of those illustrated in line, with uncoloured drawings of the Evangelists' symbols, which are a feature of the small, less luxurious manuscripts illustrated by a scribe rather than an artist-illuminator.

The Book of Dimma

THE BOOK OF DIMMA, executed in the late eighth century AD, is one of the few 'pocket Gospels' to survive. These were often completed very quickly by the scribes, unlike the larger and more sumptuous Gospel books, which were worked on for a considerable length of time. The colours are very subdued, with browns, blacks, blues and pale gold. The pictures are often not symmetrical.

The manuscript was probably written at Roscrea in County Tipperary and was the work of several scribes.

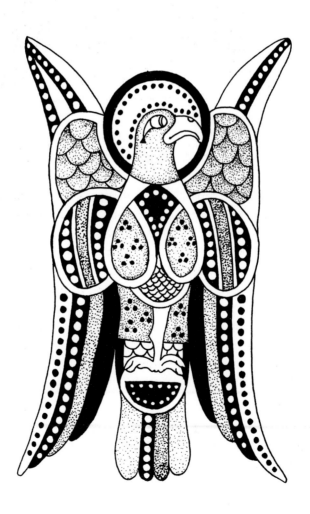

The St Gall Gospel Book

W<small>RITTEN BY AN</small> I<small>RISHMAN</small>, probably early in the second half of the eighth century AD, the St Gall Gospel is richly ornamented, mostly with spirals and animal interlacing somewhat similar to the type used on metal-work, but it is simpler and less energetic in its appearance.

In their portraits, each of the Evangelists stares rigidly forward full-face and holds a book in his hands. The whole work is impressive, but is also an example of a rather naïve and almost rustic art.

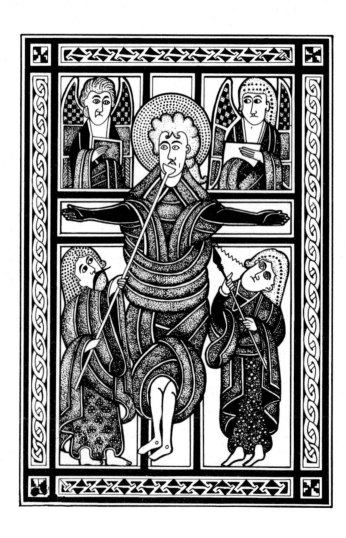

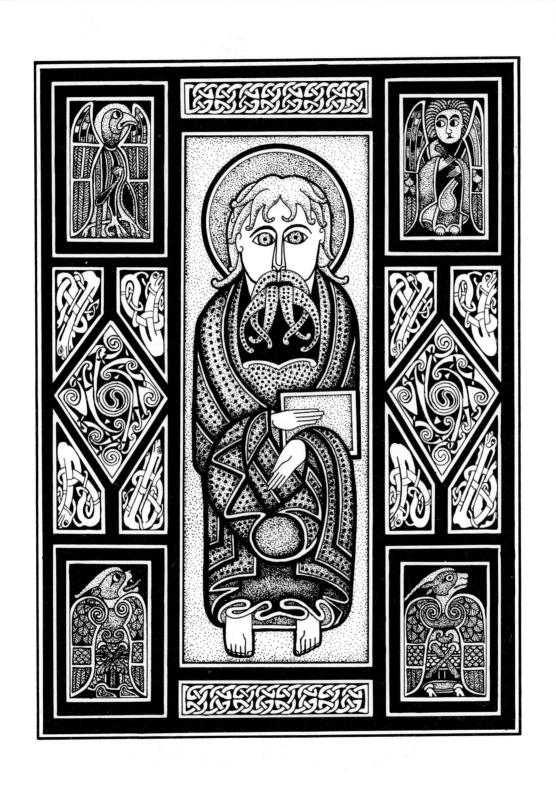

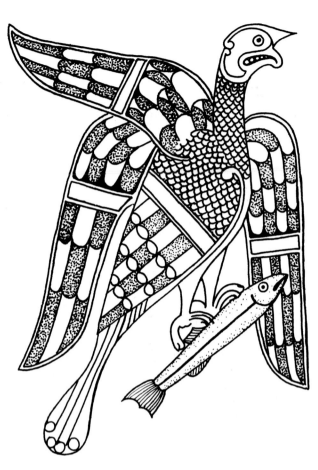

The Four Evangelists

Matthew, Mark, Luke and John were depicted in the Gospels by four symbols, man, lion, calf and eagle. These were first mentioned in the Book of Revelations, Chapter four:

And in the midst of a throne, and round about the throne, were
four beasts full of eyes before and behind. The first beast was like
a lion, the second beast like a calf, the third beast has a face as a
man, and the fourth beast was like a flying eagle. And the four
beasts had each of them six wings about him; And they were full
of eyes within; And they rest not day and night, saying, Holy,
Holy, Holy, Lord God Almighty, which was, and is,
and is to come.

It was St Jerome (AD 342–420) who first translated the Bible from Hebrew and Greek into Latin, his version being known as the Vulgate. The text became the standard Bible in the West and it was this version that the Celtic scribes used for their great books.

The explanation of the symbols is that the four together form a symbol for Christ himself. The Man and the calf reflect the humility of incarnation and sacrifice, and the lion and the eagle reflect the courage and sublimity of Christ's resurrection and ascension.

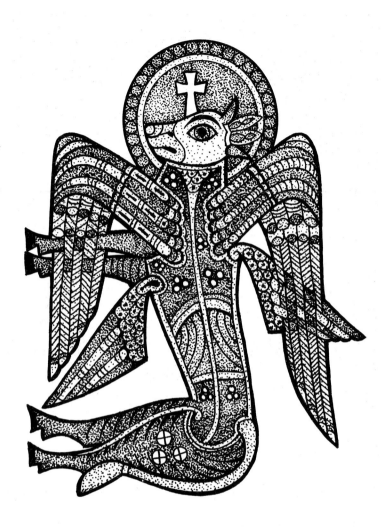

St Gregory's homilies on Ezekiel explain the symbols as the four stages of Christ's life: at birth he was a man, in death he was a calf, in resurrection he was a lion and in ascension he was an eagle.

These symbols are shown holding books and sometimes with quills in their hands.

The four-symbol presentation of the Evangelists on one page is found, for example, in the Book of Durrow, the Lichfield Gospels, the Book of Armagh, but in each of these they occur only once, while in the Book of Kells they are shown repeatedly.

They are shown with or without haloes in this form.

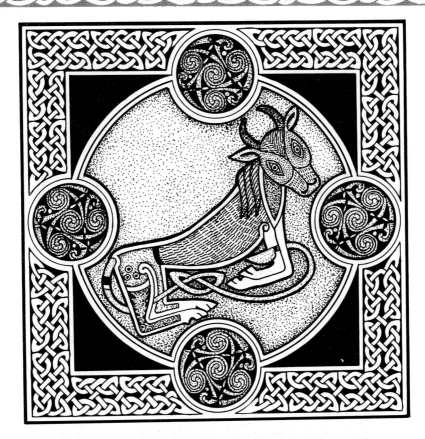

THE CONTEMPLATIVE LIFE

ALONE IN MY LITTLE HUT WITHOUT
A HUMAN BEING IN MY COMPANY,
DEAR HAS BEEN THE PILGRIMAGE BEFORE
GOING TO MEET DEATH.

A REMOTE HIDDEN LITTLE CABIN,
FOR FORGIVENESS OF MY SINS;
A CONSCIENCE UPRIGHT AND SPOTLESS
BEFORE HOLY HEAVEN.

EIGHTH-CENTURY IRISH

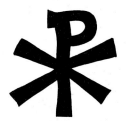

The Cross

THE CHI-RHO MONOGRAM consists of the two Greek letters X(chi) and P(rho), which are the first two letters of the name of Christ in Greek. A monogram is formed when the letter P is placed over the intersection of the X; sometimes the X is rotated so that it coincides with the stroke of the P. In AD 312, the monogram became famous when the Emperor Constantine had it painted on the shields of his army and their subsequent great victory was attributed to this. Later the monogram was enclosed within a circle, and eventually turned into the wheel-cross. The wheel symbolizes God, the motionless mover, the centre that has no dimensions and cannot turn, yet all moves around it. The circle represents wholeness, the round contours of female energy, and the cross symbolizes the four directions of movement, or male energy, in the form of the seasons. The two superimposed express harmony and balance.

On the pages of the Gospels the size and elaboration of the Chi-Rho steadily increased after the Cathach, and the Lindisfarne Gospels were the first to devote a whole page to it. The Chi-Rho introduces the genealogy of Christ in the Gospel of St Matthew; a noble lineage was highly esteemed among the Celts and Anglo-Saxons, and great importance was attached to it.

The Chi-Rho in the Book of Kells is like a complex universe of ornament, containing countless spirals within spirals and entwined forms. Three angels appear on the Chi-Rho at the moment of the nativity, as well as two lifelike moths, two rats nibbling a wafer being held by their tails by two cats, who have two mice perched on their backs. This expresses the alliance with the humblest of creatures in the presence of the sacred name of the Christ.

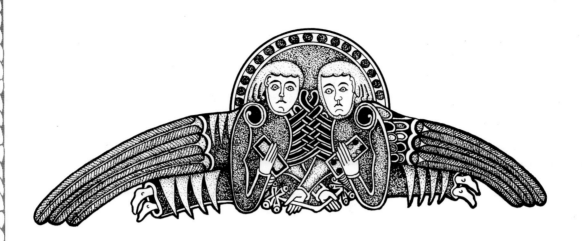

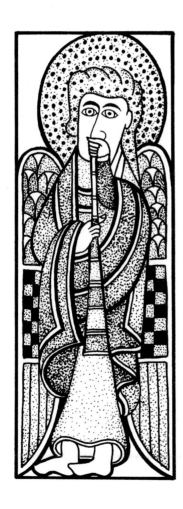

Angels and Man

The representations of human figures by
Celtic artists were influenced by the
pagan laws that forbade the copying of
the works of the Almighty Creator. In
Celtic zoomorphic ornaments the physical
appearance of man was not copied. His
legs, arms, body, topknot, hair and beard
interlaced with each other. Portraiture of a
living person, in his created form, was a
heinous crime. The portrayal of the saints
of the sacred Gospels in the Books of Kells
and Lindisfarne was that of persons who
had long departed from earthly habitation
and of the angels who were migrants of
the Heavenly Host.

Extract from Celtic Art: The Methods of Construction
by George Baine

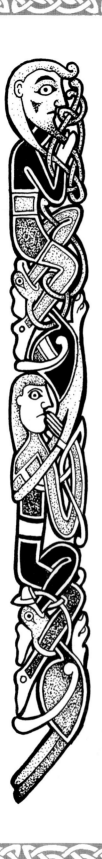

THE WORD ANGEL comes from the Greek for 'messenger'; unseen angels were a constant spiritual presence who mediated between God and man. They were held in high esteem, for they had sight of God in heaven and would be there at the Last Judgement also. They had been present at Christ's birth and surrounded him at each important moment he was on earth. They help to make clear the mysteries of faith and show themselves only to the worthy who are prepared to see.

In the manuscripts angels are shown as messengers of the word of God. There are numerous images of men in the Book of Kells, including those of warriors as well as monks. Some of the pages show groups of men with just head and shoulders showing, and it has been suggested by Dr Alexander that they may in fact portray the ancestors of Christ.

Hairstyle and colour seem to signify the position of the person portrayed. As R A S Macalister remarks in *Ireland in Pre-Celtic Times*: 'All persons of importance native to Ireland are described as having golden hair. Most persons in subordinate positions and those who are spoken of with scorn are dark-haired.' Yellow hair is long and flowing, while dark hair is short or cropped.

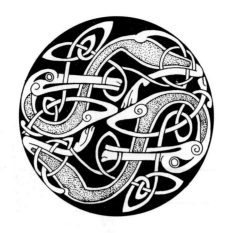

Zoomorphic Ornaments

PLANT, INSECT, FISH, reptile, bird, animal and man, the seven created beings, were sacred to the Celts and all take their place in the Book of Kells. They believed that God gave seven faculties to man: sight, smell, taste, hearing, feeling, good and evil.

Many of the pre-Christian gods were depicted with bird or animal parts. Shape-changing was said to have been practised by the Druids and their gods in early legends, and by semi-mythological characters who adopted an animal form. It is said that St Patrick was able to shape-change, one time turning into a stag to escape capture by pagan warriors.

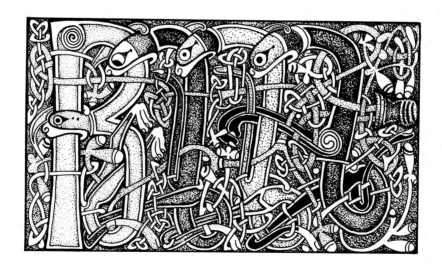

Zoomorphic ornaments are those based on animals, birds and reptiles. Anthropomorphic ornaments are those based on the human body. They make an early appearance in the art of Bronze Age Britain and Ireland, and in European forms of Celtic art. Zoomorphic and anthropomorphic ornament show us that nothing is as it seems: winding tails turn into the branches of a plant; cats and dogs have bird bodies and so on. Craftsmen fashioned them into a complex contortion of bodies that still conformed to nature.

Although there are fine zoomorphic carpet pages and borders in many of the great Gospels, it is in the Book of Kells that such art reaches its heights. Christ was identified and accompanied by a large number of different symbols, including the fish, the snake, the lion and the peacock.

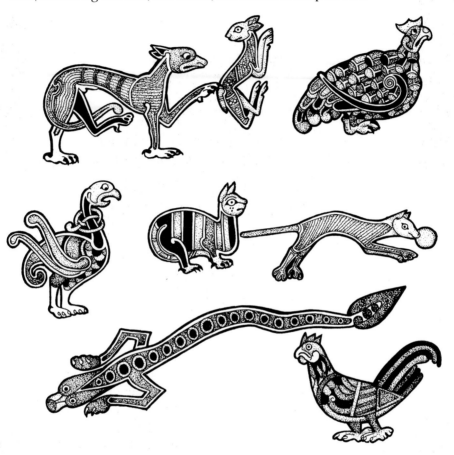

The fish was the earliest Christian symbol for Christ and the Soul. This is thought to have came about because the letters of the Greek word for fish are the first letter in each word of the phrase 'Jesus Christ, the Son of God, Saviour'.

The snake symbolizes Christ's resurrection, due to the belief that a snake regained its youth with the shedding of its skin. In the Book of Kells snakes are frequently depicted with duck-like heads and the tails of fish.

The lion was also a symbol of resurrection. The portrayal of human heads in the mouths of beasts has a long tradition, and recalls the story of Daniel in the lion's den.

According to ancient belief, codified by Isidore, the flesh of the peacock was so hard it did not putrefy, so in its symbolic form it represents the incorruptibility of Christ.

Every winged being is symbolic of spirituality. According to Jung, the bird is a beneficent animal representing spirits or angels, and the souls of the faithful. It is thought that the birds of the Lindisfarne Gospels, painted by Eadfrith, may be cormorants, inspired by the rich wildlife that surrounds Holy Island.

Dogs are an emblem of faithfulness, and in Christian symbolism they have the function of the sheepdog, guarding and guiding the flock, so at times become an allegory for the priest.

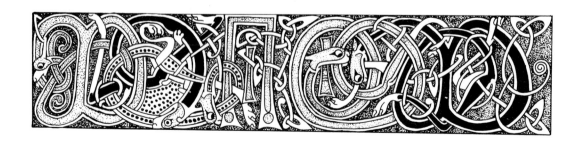

an irish blessing,

may the road rise to meet you,
may the wind be always at your back,
may the sun shine warm upon your face,
the rains fall softly upon your fields
and until we meet again,
may god keep you in the palm of his hand.

traditional

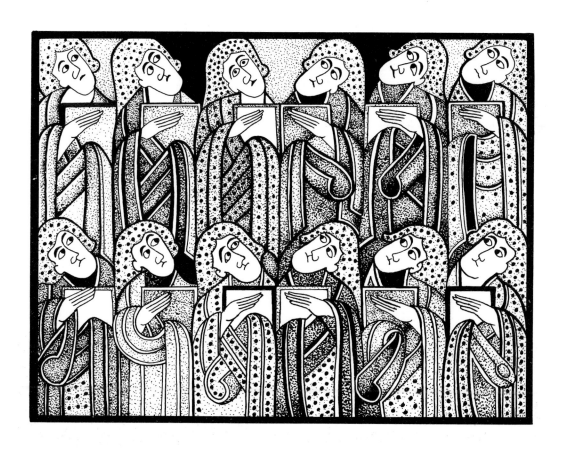

The Tree of Life

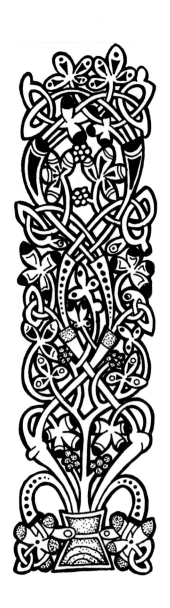

Trees and plants were sacred to the Celts in pre-Christian times because their roots lay deep in the underworld, their trunks in the earth world and their branches reached high into the sky world.

The decoration in the Book of Kells presents a remarkable contrast to nearly all the early Irish manuscripts, and the foliate ornament that is used to such good effect here is entirely unknown in earlier Celtic work.

J A Brunn describes its appearance in the Book of Kells as follows:

> The element appears, to begin with, among flourishes and terminals, in the shape of lightly sketched branches with leaves and flowers, sometimes preceding from vases. Of a more elaborate nature are the scrolls of foliage which are seen to fill in, as a surface decoration, long, narrow borders or panels in grand illuminated pages . . . Thus a branch of foliage is frequently seen to evolve from the open jaws of a nondescript, while at the same time the tail of the beast presents the appearance of a trefoil or lance-shaped leaf.

Some of the foliate ornament is probably mistletoe, which held a special place because it is rooted above the ground in the bark of trees and was therefore not part of the underworld.

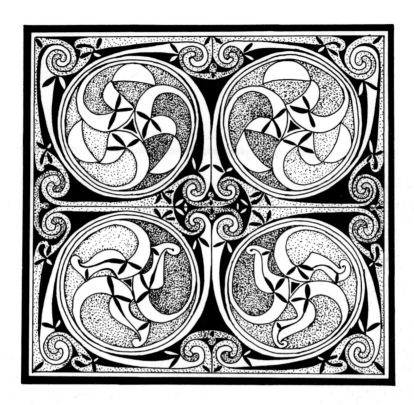

Spirals

THE NATURAL PATTERN of growth which we see time and again in nature is the spiral. To many different cultures past and present it is symbolic of eternal life, the whorls representing the continuous cycle of life, death and rebirth.

Surrounded by water, the Celtic monks were constantly reminded of the flow and movement of the cosmos as they worked.

In Neolithic times, passing a spiral barrier seems to have been necessary to step within the inner sanctuary of a stone burial chamber, such as the entrance stone blocking the entrance to the tomb at Newgrange, the passage beyond symbolizing the soul moving from death to find rebirth at the still centre.

The inner chamber has been used for both meditation and initiation, and the early Celtic saints continued this tradition by using a rock cavity for meditation and prayer.

There is a continuous line of evolution of the spiral in three-dimensional art in Ireland and the British Isles from prehistoric times. Though the single-coil spirals are found in many parts of the world, it was the Celts who developed them: first, on themselves, their jewellery, weapons and ornaments for the horse; and later in the masterpieces of metalwork and the decorated books of the early Christian era.

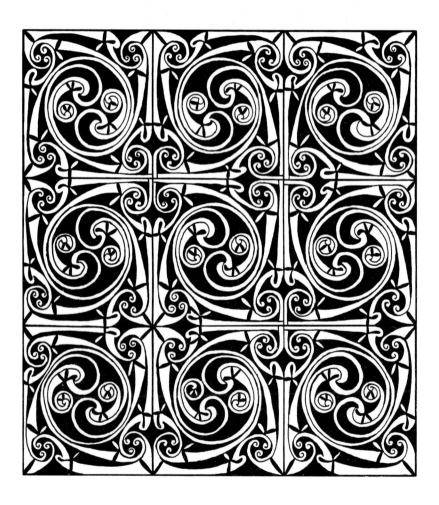

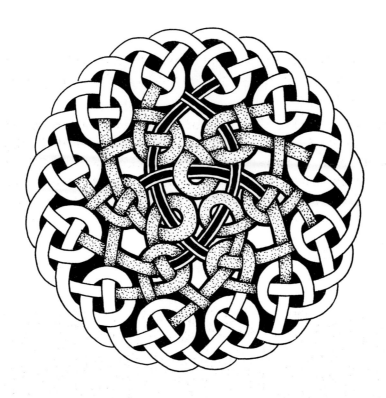

Interlaced Knotwork

I T IS BELIEVED THAT our souls are a fragment of the divine and that, through a series of successive births, they can rid themselves of impurities until, achieving the goal of perfection, they can return to their divine source. The interlaced knotwork patterns, with their unbroken lines, symbolize this process of spiritual growth; following the lines occupies the conscious mind with a demanding repetitive task, as you would use a mantra or rosary beads.

There are very few peoples who did not use some kind of interlaced pattern, derived from plaiting or weaving, in their decoration on stone, metal or wood. Scholars believe that the first cross-slabs to appear with multi-strand interlacing date from around the seventh century AD, the most famous of them being from Cardonagh and Fahan Mura. Through the centuries the Celtic crosses and stone slabs became decorated with very complex interlaced patterns and other equally intricate decoration and were painted with bright colours.

In the middle of the seventh century AD the first interlacing appears in insular book decoration on the colophon page at the end of St Matthew's Gospel in a fragment of the Durham Gospels. This page has an unusual shape of three Ds, one on top of the other. The ability of the knotwork to expand or contract, like liquid filling a designated passage by adapting itself through necessary change in its pattern, made it a useful decorative tool for the Celtic scribe, whose skill gave it new dimensions of intricacy.

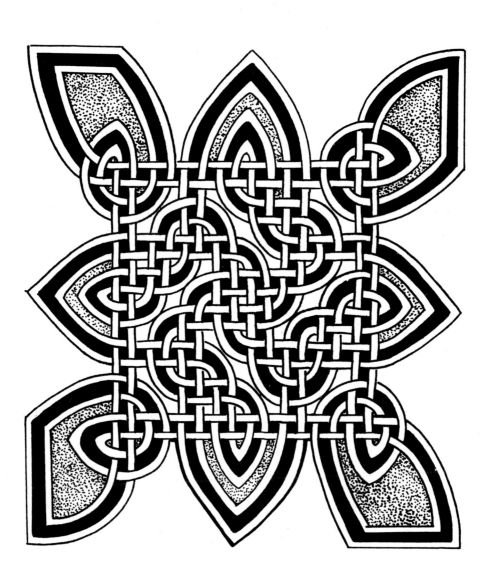

Key Patterns

KEY PATTERNS are really spirals in straight lines. When connected, they become a processional path leading through a complex labyrinth. It is a journey through progressive levels of experience – physical, mental and spiritual. On religious festivals, the adept would step barefoot on to a labyrinth that had been cut into the ground and being the sacred dance, moving in a clockwise direction in deep contemplation, absorbing the earth's energies with every step until reaching the sacred Omphalos at the very centre, then retracing his steps anticlockwise to complete his ritual.

This journey of devotion is the equivalent of a pilgrimage to Jerusalem for Christians.

Carvings have been discovered of key patterns engraved on mammoth tusks dating from 20,000 to 15,000 BC, found in the Ukraine and the former Yugoslavia. The British Museum in London has an ivory carving from Egypt dating from around 3,500 – 3,000 BC of a priest whose robe shows a key-pattern panel and interlacings on its borders.

Some Chinese key patterns belonging to periods before 1,000 BC are very similar to the later decoration on stone slabs, crosses and the decorated manuscripts.

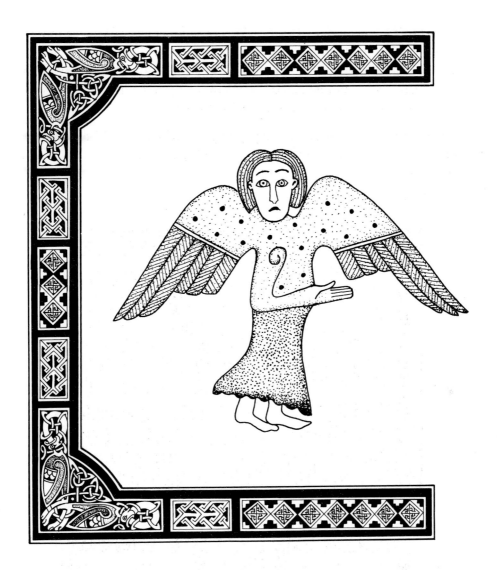

thanks to thee, o god.
that i have risen today,
to the rising of this life itself,
may it be to thine own glory.

Extract from the Carmina Gadelica by Alexander Carmichael

SOURCES AND INSPIRATION
FOR THE ILLUSTRATIONS

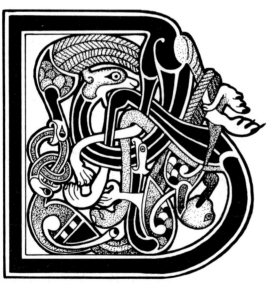

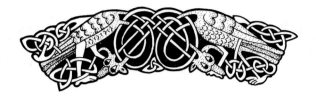

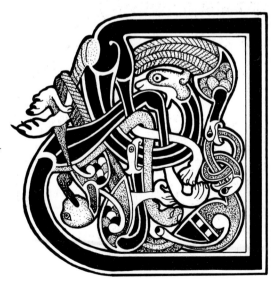

Further Reading

Davis, Courtney, *The Art of Celtia*, Blandford, 1994

–*Celtic Art of Courtney Davis*, Spirit of Celtia, 1985

–*The Celtic Art Source Book*, Blandford, 1985

–*Celtic Borders and Decoration*, Blandford, 1992

–*Celtic Design and Motifs*, Dover, 1991

–*Celtic Image*, Blandford, 1996

–*The Celtic Mandala Book*, Blandford, 1993

–*The Celtic Saint Book*, Blandford, 1995

–*The Celtic Tarot*, Aquarian, 1990

–*The Return of King Arthur*, Blandford, 1995

Baine, George, *Celtic Art: The Methods of Construction*, Constable, 1951

Blackhouse, Janet, *The Lindisfarne Gospels*, Phaidon Press, 1981

Brown, Peter, *The Book of Kells*, Thames & Hudson, 1980

Carmichael, Alexander, *Carmina Gadelica*, Scottish Academic Press, n.d.

Henderson, George, *From Durrow to Kells*, Thames & Hudson, 1987

Laing, Lloyd and Jennifer, *Art of the Celts*, Thames & Hudson, 1992

Meehan, Bernard, *The Book of Kells*, Thames & Hudson, 1994

Nordenfalk, Carl, *Celtic and Anglo-Saxon Painting*, Chatto and Windus, 1977

Quiller, Peter, and Davis, Courtney, *Merlin Awakes*, Firebird Books, 1990

–*Merlin the Immortal*, Spirit of Celtia, 1987

Roberts, Forrester, and Davis, Courtney, *Symbols of the Grail Quest,*
 Spirit of Celtia, 1990

Romilly Allen, J. *Celtic Art in Pagan and Christian Times*, Methuen, 1993

Index

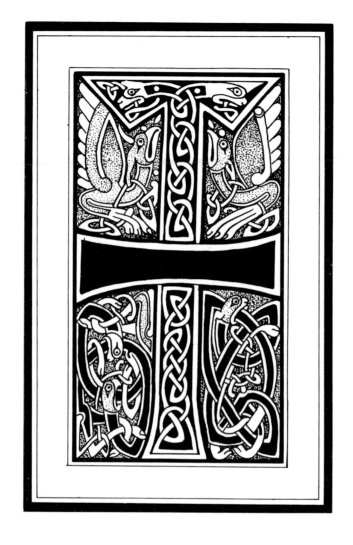

he is pure gold,
he is a heaven round a sun,
he is a vessel of silver with wine,
he is an angel, he is wisdom of saints,
whoever doth the king's will.

a verse from the life of st moling,
the calendar of oengus, trans. whitley stokes